Mughal Jewellery

Mughal Jewellery

A Sneak Peek of Jewellery Under Mughals

Dr. Nafisa Ali Sayed

PARTRIDGE

To order additional copies of this book, contact
Partridge India
000 800 919 0634 (Call Free)
+91 000 80091 90634 (Outside India)
orders.india@partridgepublishing.com

www.partridgepublishing.com/india

CONTENTS

ACKNOWLEDGEMENT

The book would not have been completed without the support and guidance of a few people, who I would like to thank.

I owe my loving thanks to my husband Ashfaq Motiwala, my daughter Ayat and my parents. Without their encouragement and understanding it would have been impossible for me to finish this work. My special gratitude is due to Renu Manjunath to share her '**Karigari Collection**' for pictures in the book. Lastly, I would like to thank for those whose names could not be included but their support has been instrumental in the completion of this work.

The support of the Partridge Publications and its staff is gratefully acknowledged.

Dr. Nafisa Ali Sayed

CHAPTER 1

Introduction

The rich and old tradition of jewellery making has been well-documented through paintings as well as sculptures reflecting their development over ages. In fact, the art of metallurgy reached its zenith of delicacy and decorative effect in the making of jewellery. Use of jewellery was not solely meant for affluent but also for the humbler strata. Though the kind of jewellery they wore differed. For instance, the affluent class jewellery included precious stones and gold whereas the humbler strata have to suffice with semi-precious stones, silver, brass and lac.

In the due course of time, the 'Art of Jewellery' began to be closely associated with the growth of human civilization. The use of jewellery gradually came to be a symbol of human status that includes the pastoral society of India reflecting the socio-economic status in the societal setup.

The earliest examples of jeweller in the Indian subcontinent can be traced to the Indus Valley Civilization encompassing the areas in the present-day India and Pakistan. Even about 5,000 years, the evidences of panoramic survey of Indian jewellery indicate to the primitive inventiveness to adorn the human form with the aid of ornaments. With the discovery of precious and semi precious metals such as gold and recognition of its intrinsic value, that initiated the development of the jewellery form that we know of today. The use of various minerals and materials became to be used by different civilizations at the same time adapting to their specific regions. However, the development of metallurgy that took place in the Indus Valley Civilization is unparalleled to any of its contemporary.

In terms of materials used in the prehistoric times, beads were quite popular. In fact, this seems to be the case in almost all early societies. The use of beads in large quantities was initiated in the Aurignacian period[1], and gradually it became

[1] The Aurignacian culture refers to an archaeological culture of the Upper Palaeolithic, found in Europe and southwest Asia broadly spanning within the

widespread in the Neolithic as well as post-Neolithic periods.

It is human nature to appreciate beauty, and use of jewellery seems to be a reflection of just that, wherein the human form is ornamented. Jewellery was worn not solely for its value but also specific religious as well as superstitious reasons. Every single piece of jewellery denoted a unique design that was crafted through any of the several techniques such as enamelling, etching, stone encrustation etc. Although retaining its conservatism in basic forms but over ages the crafts has attained a kind of finesse and diversity of detail in its expression.

With the advent of the *Mughals,* the craft got a fresh vitality that added to the creativity of the Indian artisans, in particular to the level of sophistication achieved under the patronage. The jewellery served as adornment as well as indicated the wearer's power. In accordance to the then

period from ca. 45,000 to 35,000 years ago. The name is likely to have originated from the type site of Aurignac situated in the Haute-Garonne area of France.

local custom, the high-ranking officials in the *Mughal* court, gifted jewellery and precious jewels as a symbol of royal favour. The opulence of craftsmanship of jewellery reached a different level, wherein plain gold or silver jewellery wasn't enough to quench the thirst for magnificence under the *Mughals*. The *Mughal* patronage encouraged the concoction of indigenous and Persian lapidaries to develop new ideas into the craft, who were guided under the discerning eyes of the patrons. Emperor *Humayun* himself had brought several skilled Iranian goldsmiths, who worked in the *Mughal* workshops.

Most of the *Mughal* jewellery was accomplished by the delicate art of enamelling and gem or stone encrustation. Both these techniques demanded boldness of execution as well as attention of detail. This technique could be traced back during the Sultanate period wherein, the use of glazed tile decoration was in vogue.

The Indian jewellery comprises ornaments for every part of the body from head to toe. However, each of these ornaments is distinct in their design owing to the variations within the same region.

It was *Mughal* period that embarked upon one of the opulent eras of jewellery art in history of India that is well-documented through chronicles and paintings. In fact, the earlier *Mughal* paintings indicate that the era of *Akbar*'s reign gave a new life into the art, crafting a range of exotic deigns.

In April 1526, when *Zahir ud din- Muhammad Babur* defeated *Ibrahim Lodi* at *Panipat* establishing the *Mughal* Empire. Subsequently, he almost immediately, dispatched his son *Humayun* to take custody of the treasures at Agra with precise instructions to acquire a famous diamond that was assumed to weigh 8 *mishqals*. In search of the diamond, the entire treasury was despoiled, the officials interrogated, but the diamond could not be found. It is said that one of the servants in face of dire consequences, finally pointed towards the royal *zenana* (women quarters). When *Humayun* entered the women's quarters, "the female members of *Ibrahim Lodi's* family were found weeping, so he assured them theory honour would be safe with his hands and that he would treat them according to their high stature. It was then that *Ibrahim Lodi's* mother went silently into a room and emerged with a gold box,

which with trembling hands, she handed to the young prince. *Humayun* opened the box and took out the diamond."[2] This diamond was supposedly the '*Koh-i-Noor*' (the ray of light) according to a legend and with this began the *Mughal* tryst with jewels.

In fact, the *Mughal* gem coffers swelled with every succeeding generation of emperor who appropriated wealth of the Indian states. It is said that, the chronicles found it difficult to count the number of precious stones and other items of the treasury so much that they had to resort to weights in their accounts. The treasury included drinking cups, saddles of gold and silver, swords and blades, chains of pearls, diamonds, jewelled brooches for the hair and much more. The total quantity was known solely to the keeper of the royal treasury.

In the 17th century, the *Mughal* India was a magnet for international trade, wherein the European powers fought with each other to gain

[2] *Baburnama*, a memoir of Babur, the founder of the Mughal Dynasty. The book is translated in English by Annette Beveridge

the attention of the emperor. In this pursuit, several ambassadors, gem dealers, traders came to India from different parts of the Europe. One such ambassadors was Sir Thomas Roe who was sent by King James I to Jahangir's court in the year 1614 to negotiate economic possibilities and permission.

Despite the fact, India being one of the principle supplier of diamonds and other gems, it still was one of the organized markets for gems in the *Mughal* court. This opportunity to impress the emperor was never missed out on by the European powers. In fact, it would not be wrong to say that the loyalties to a *Mughal* Emperor were best demonstrated by means of *nazraana* (gifts that were offered to the Emperor and the royal family in honour). This custom was religiously adhered by nobles and vassals to appease the royalty, wherein they vied each other in the worth of the *peshkash* that went to immodest extremities.

Apart from this, in accordance to an imperial decree the Emperor was to be obliged with the finest gems in the empire and had appointed agents to do the job in the principal gem centers.

References have been made in *Tuzuk i-Jahangiri,* that gems were acquired from places such as Goa and Gujarat especially by traders and foreign potentates seeking special favours and concessions from the emperor. [3] Furthermore, Italian traveler *Manucci* too accounts, "all the wealth of the defunct"[4], wherein the wealth of the deceased noblemen was not hereditary and after his demise, went to the royal treasury swelling coffers more. In fact, these norms were practice under *Akbar* too. This practice though effectively curbed the ambitious plans of courtiers. The women of the harem were not spared from this practice, thus indicating the policies regarding jewels and wealth management under the *Mughals.*

[3] ***Tuzuk i-Jahangiri***, *a memoir o the Emperor Jahangir*

[4] ***Storio do Mogor***, Niccolao Manucci. An account by Italian writer and traveler who worked in the court of Dara Shikoh

CHAPTER 2

Hallmark of Artistry

The period under the *Mughals* from 1526 roughly up to 1857 saw the development in the field of art and architecture with new ideas confluence with the native decorative and crafting techniques. One of the finest examples being the Throne of *Shah Jahan* (1592-1666), it is believed to have the *Koh-i-Noor* diamond held dangling. It was once a part of the loot sacked by *Nadir Shah* in 1739, but it is believed to have been destroyed soon after his death.

The *Mughal* dynasty was established by the successor of *Timur* or *Tamerlane*, Babur who came to India in 1526. Amongst the many traits that *Babur* and his successors got from their ancestral genes was love of arts as well as a practice of writing memoirs. It is the reliance on these memoirs that an insight to some interesting and importance aspects of life under

the *Mughals* can be understood. Thus we have a view of the doings of the emperors and their followers and the environment they created as had never existed earlier. *Humayun*, son of *Babur* continued this legacy despite being ousted from his throne. While living in exile, he stayed in Iran or Persia that was at its cultural peak. He was so impressed by the Iranian craftsmen, that once he regained the reigns of the *Mughal* India in 1556, he persuaded some master-craftsmen to accompany him on his journey. These masters initiated the beginning of a new era of art and craft under the *Mughals*, wherein the artisans in the royal *karkhanas* in Agra were trained by them. This distinctive synthesis of Indo-Persian art is continued till today.

In fact, the artists and craftsmen of the *Mughal* court were a part of the inner coterie of the royal household, so much so that they travelled along with the emperor on his numerous campaigns and pleasure trips to various parts in the country. This was practiced in an attempt to allow the painters and jewellers to capture the essence of flora and fauna that could be further incorporated in the work of art. The craftsmen were invited not only

from different parts of the country but also from different countries of the world such as Venice, Iran, Turkey, and England to accomplish imperial orders. These trends added to the rich heritage of craftsmanship. References of goldsmiths, enameller or *minakar* have often been described in *Ain-i-Akbari*. *The Akbarnama* also shows illustrations of dancers, both wearing clearly differentiated styles of jewellery in accordance with their origins.

Art reached new heights under *Mughal* patronage, as the Emperors were not merely patrons but informed connoisseurs. For instance, Emperor *Jahangir* could clearly point out in any given composite painting, attributes of different artists in different sections of the work. This clearly indicates the amount of detailing and attention given towards the art of ornamentation including jewellery.

The love for precious stones under the *Mughals* is accounted by Sir Thomas Roe[5] in his memoirs. He describes the jewels worn by the Emperor

[5] Sir Thomas Roe was ambassador to the Mughal court during the reign of Emperor *Jahangir*. He was sent

Jahangir on his exit from *Ajmer*. "On his head he wore a rich turban with a plume of heron tops (aigrette) not many, but long, on the side hung a ruby unset, as big as a walnut, on the other side a diamonds great, in the middle an emerald like a hart, much bigger. His sash was wreathed out with a chain of great pearls, rubies and diamond drilled; about the neck he carried a chain of most excellent pearls three double …his elbows amulets set with diamonds, on his wrist three rows of several sorts. His hands bare, but almost on every finger a ring."[6] Quoting about the jewels worn by the ladies of the harem (royal household), he says "If I had no other light, their diamonds and pearls had sufficed to show them."[7] In addition to this, he also accounts the solar weighing ceremony of the emperor, wherein the scales were of beaten gold. The ceremony necessitated the king to be weighed against jewels, gold, silver and other precious items. This ceremony was also accounted by another writer, Hawkins who was the Lieutenant-General of the fleet sent out

by King James I of England to seek concessions and trading privileges.

[6] Journal of the mission to the Mogul Empire

[7] Ibid

to India and Aden for trade in 1607. Hawkins asserts that Jahangir wore his diamonds by turn, never repeating a one for a while year.

Even the memoir of the Emperor Jahangir, *Tuzuk-i-Jahangiri*, testifies to the love of jewels under the *Mughals* and the keen attention given to the adornment. He accounts his gift to son *Khurram*, later to be Emperor *Shah Jahan,* a jewelled *charqab*[8], the fringe and collar of which were decorated with pearls, an Iraqi horse with a jewelled saddle, a jewelled sword with a special belt that has been taken after the conquest of *Ahmadnagar* and was very famous, and a jewelled dagger.

The practice of giving presents to the sovereign ensured that there was a constant flow of money and valuables to the royal treasury. This custom was also a means of indirect taxation. This custom was considered to raise the prestige of the giver and elevate their social status in society. The Emperor too gave gifts, but was reciprocated with gifts more in value.

[8] *Charqab, a piece of clothing primarily worn in Central Asia*

The art of encrustation of jade with floral patterns had begun to develop under the *Mughals* around Delhi. This ornamentation technique was used profusely to decorate mouthpieces of *hookahs*, lockets hilts of daggers and much more. Although, it wasn't an expensive technique but the effect it created was definitely mesmerizing that was primarily dependent upon the skill of the craftsmen. Rajasthan and in particular Jaipur became one of the chief center for production of jewellery during the *Mughal* period.

With the decline of the *Mughals,* the patronage of the craftsmen declined too. Henceforth, the craftsmen fled to different parts of the country, wherein the dynastic traditions and prejudices led to the degeneration of mastery that was developed under the *Mughals*.

CHAPTER 3

Motifs

The *Mughal* India was melting pot of different cultures that drew inspiration from religion and natural surroundings. Henceforth, there was no dearth of motifs that were borrowed from different medium, and then adapted in size and scale.

Most of the motifs were floral inclusive of scrolling vines and often animative too. The floral design is among the admired motifs in Indian jewellery such as *champa* or jasmine. In fact, most of the ear ornaments and rings were shaped in the form of flower that was ornamented with different techniques.

The use of birds and animals as motifs was quite popular in the pre-*Mughal* times. The animative symbolism was influenced by religious and superstitious beliefs of the native people. Serpent,

fish and peacock too were used for jewellery especially neck, ears, nose and head ornaments. Serpent signified quick potency and eternity of cyclic time course. Fish was one of the incarnations of the Lord *Vishnu* in accordance to the Indian mythology as well as an auspicious symbol denoting abundance. Last but not the least; a peacock represents beauty and immortality. The fish motif seems to have continued as a popular motif even under the *Mughals*.

Other animals such as lions and elephants were profusely used too. Lions symbolize qualities of strength, courage as well as sovereignty, whereas the elephant symbolize visibility, calmness, strength as well as gentleness. Among the south Indian jewellery, the *Kirtimukha* (lion faced) motif is very popular. The mythical bird with two heads and a body namely '*gandabherunda*' is a beautiful piece of art. Adornment by employing these animal motifs was a means to reflect the qualities of the wearer.

With the advent of *Mughals,* the use of animal motifs considerably declined, owing to the prime reason that depiction of human or animal figures

were prohibited by Islam. However, several new motifs were slowly and gradually incorporated in the fabric of ornamentation such as use of star and crescent. Although the use of star and crescent was in vogue earlier but came to be closely associated with the Islamic adherence to lunar calendar and beliefs, more popularly known as the 'emblems of Islam'. Nevertheless, the *Mughals* were greatly influenced by the local superstitions such as the use of gems in accordance to the astrology, and wearing the popular '*Navratna*'.

CHAPTER 4

Varieties of jewellery under the Mughals

The *Mughals* contributed in almost all the fields of development including jewellery. The use of jewellery was an integral part of the lifestyle be it the king, men and women in the service or even the king's horse. Jewellery was largely influenced by the local customs and traditions. The *Ain-i-Akbari*[9], mentions ornaments for different parts of the body and gives details of the work done by different people in making the pieces and gives the existing rates. In accordance to him, the department of precious stones was presided over by Darogah (Superintendent) as well as skilled jewellers. This team sorted out the jewels from the rust of confusion. He states that

[9] *Ain-i-Akbari,* a comprehensive account of life and times of *Akbar* written by *Abul Fazl (the court chronicler)*

diamonds, emeralds, rubies were classified into two classes whereas pearls were string by scores and had 16 classes. The sorting out into strings was completed with an affixed imperial seal at the end of each bundle of strings. This practice was followed to avoid losses arising from unsorting. This was accompanied with a detailed description attached to each pearl, to avoid disorder.[10]

Bernier, has recorded that "the Indian make excellent muskets and fowling pieces and such beautiful ornaments that it may be doubted if the exquisite workmanship of these articles can be exceeded by any European goldsmith."[11] The traveller further accounts that under the *Mughal* rule everyone from *Omrah* (nobles) to soldiers, men and women in Emperor's service wore silver and gold ornaments. In fact, *Omrah* and private soldiers were not allowed to wear gilted ornaments that clearly indicate the opulence of the empire. In fact, the credit to preserve the arts goes to

[10] Ibid

[11] *'Travels in the Moghul Empire'*, Francois Bernier. a French traveller who has accounted his travel accounts under the Mughals. Bernier, who was in India in 1658-59

the monarchs and principal *Omrahs* who kept a number of artists on their payroll if not by will then by the *korrah* (whip)"[12]

It was mandatory for the Emperor's person to be adorned by jewels as it was considered to be an important part of the magnified power. To the extent, that the austere *Aurangzeb* who lived an extreme simple life, he too was seen wearing diamonds of extraordinary sizes and value. [13]

HEAD ORNAMENT

Turban jewellery was considered a privilege of the Emperor, as well as his close family or members of his entourage inclusive of his horse. The constant change in the influences from Europe can be clearly witnessed in the design of the turban jewellery. For instance, *Akbar* stuck to Iranian trends of the time by keeping a feather plume upright at the very front of the turban. In contrast, *Jahangir* initiated his own softer style with the weighed down plume with a large pearl.

[12] Ibid

[13] Ibid

Taking a step further his son, *Shah Jahan*, appears to have been inspired from Europe, wherein he wears a new stylized *jigha* on similar lines of Dutch jewellery designed by Arnold Lulls resembling jewels worn by James I in portraits bought by Sir Thomas Roe to the *Mughal* court. However, by the time of *Aurangzeb* and his successors the form became more ubiquitous. Usage of turban jewellery continued to be important in the provincial courts too even after the decline of the *Mughal* authority. Turbans were usually heavily set with jewels and fixed firmly with a gem set *kalang*i or aigrette. Several of the most extravagant stones in *Mughal* India, similar to ones found in Ottoman Turkey, Safavid, Zandid, as well as Qajar Iran, were adorned by men in *sarpech*. Another variety of head ornament worn by men was *sarpatti*. Men paralleled women in terms of adornment so much so that jewellery often rivaled with that of their wives. This clearly states that use of jewellery was considered a status and wealth symbol.

With this in mind, even women had a variety of head ornaments such as *Binduli, Kotbiladar. Sekra. Siphul, tikka* and *jhumar*. These head

ornaments worn by women varied from region to region in terms of designs. In addition to this, the braid ornaments constituted an important part of women head ornaments. In fact, several poems are centered on the glories of the Indian women with lustrous hair.

Varieties of head jewellery worn by men and women are enlisted below:

Name of the Ornament	Description
MEN	
Jigha **and** *Sarpatti*	The *jigha* and *sarpatti* were of enameled gold, set with diamonds, rubies, emeralds, sapphires, pearls and other gems. Varied designs according to the different regions of India can be seen in turban jewellery.

Sarpech	The royal personages while holding a court and other on festive occasions, used to wear an ornament called *sarpech* on their turbans. Thus was often studded with precious jewels. **Sarpech** is the ornament worn in front of the turban. It was often extended into a golden band set with emeralds, rubies, and diamonds.
Kalgi	**Kalgi** is a black heron's plumes with a pearl suspended at its tip, its stems bound with gold or silver wire, worn projecting backward in the turban, normally behind the *sarpech*.

Mukut	***Mukut*** is a multi- peaked crown in precious metal, frequently ornamented with gemstones and enamel. Although seldom in actual use during early *Mughal* times, the *mukut* was often depicted in miniature paintings symbolically hovering over the head of a ruler. In the late *Mughal* period, *mukuts* achieved a state of great elaboration and were worn both by the *Mughal* emperor and provincial rulers.
Turra	*Turra* is a turban ornament, often in the form of a bird from whose beak, is suspended a multiple- strand pearl tassel, each ending with an emerald and a small gold tinsel tassel.
Kalangi	The turban itself would be heavily encrusted (with jewels and fastened with a gem set *kalangi* or aigrette).

WOMEN	
Binduli	*Binduli*, which is a smaller than a gold *mohur* coin, worn on the forehead. *Kotbiladar* consists of five bands and a long center drop, worn on the forehead.
Kotbiladar	*Kotbiladar* consists of five bands and a long center drop, worn on the forehead.
Mang	*Mang* is a chain or string of pearls worn over the hair part.
Sekra	*Sekra* is a seven or more strings of pearls linked to studs and hung from the forehead to conceal the face. It is often worn at marriages and birth celebrations.
Siphul	*Siphul* is a head ornament resembling a marigold.

| *Tikka* | The forehead ornament, *tikka*, is usually attached to the hair with the adornment hanging at the forehead, would be gold set with diamonds, rubies and corals and coloured beads, made usually of precious and semi- precious stones and worn by brides, most of these pieces are reserved for special occasions. *Tikkas* are a traditional form of Indian jewellery that is worn from the part of the hair to the center of the forehead much like a hanging *bindi*. |

Jhumar	The *jhumar* is worn on one side of the forehead or above the ear. These are marvelous combinations of gems and pearls. An outstanding feature of most old pieces is that the reverse of the *jhumar* also had an interesting work. It was popularly worn by the Muslim women on the side of the head, generally but not always as an indication of marriage consists of a series of chains or strings of beads or pearls, spreading out from an ornamental spacer and attached by hooks to the hair.

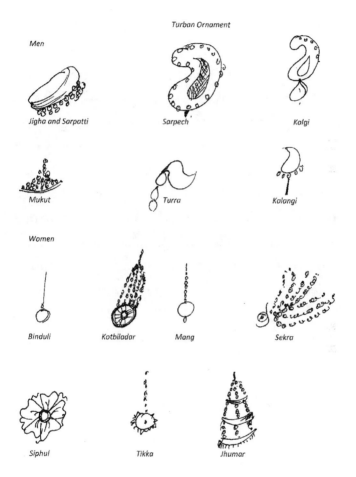

Turban Ornament

Men

Jigha and Sarpatti

Sarpech

Kalgi

Mukut

Turra

Kalangi

Women

Binduli

Kotbiladar

Mang

Sekra

Siphul

Tikka

Jhumar

EAR ORNAMENT

In accordance to the accounts of Tavernier, during the reign of Emperor *Aurangzeb*, there is "no person of any quality that does not wear a pearl between two closed stones in ear"[14]. *Mughal* paintings have represented such earrings quite often. In fact, such earrings are seen in miniatures even predating *Jahangir's*. Ear ornaments were worn by men and women. However, the men limited themselves to earrings or studs whereas women had a wide variety of ear ornaments to choose from. Ear ornaments were quite popular under the *Mughals. Bali*; *Mor-bhanwar, jhumkas, kanphool, pipal patra or papal patti, Gajra* and *paunchi* are worn on the wrist and these too are floral motifs.

[14] Jean-Baptiste Tavernier has accounted the riches and splendor of the Mughals in his book, '*Travels in India*'. Tavernier was a traveller, merchant from France, who came to India during the 17th century.

Name of the Ornament	Description
Bali	*Bali* is a circulet with pearl.
Mor-bhanwar	*Mor-bhanwar* is a peacock –shaped ear pendant.
Kanphool	The ear ornament, *kanphool*, is in the shape of a blooming motif flower and is a symbol of happiness and prosperity. *Karnphul* ear ornament or stud was usually shaped liked the magrela flower (nigella sativa).
Jhumkas	The lower bell-shaped drops or *jhumkas* were also quite prevalent in the *Mughal* era.
Pipal patra/Pipal Patti	The *pipal patra*, of northern India and Gujarat, has a central leaf motif from which bunches of finely shaped *pipal* leaves cascade. *Pipal-patti* (*papal leaf*) is a crescent shape with leaf pendant; eight or nine worn in each ear were prevalent.

Gajra	*Gajra* and *paunchi* are worn on the wrist and these too are floral motifs. The *gajra* is made in gold and pearls. From a distance they appear as if the base of intertwined gold wire is of golden grass.
Paunchi	*Paunchi* is made of a number of pieces in the shape of a flower. These are strung together and made into a bracelet.

NECK ORNAMENT

Men and women wore neck ornaments of different kinds made pearls and precious stones. In fact, necklaces of elaborate patterns, marriage *thalis* for woman and pendants, necklets, lockets for chains form an interesting topic for research in itself. Some of the neck ornaments for men included *Latkan*, *amala* necklace as well as *mala*. These ornaments were designed using graduated lengths put together. In addition to this, men also wore strings of pearls as well as gemstone beads around their neck and even turbans.

Neck ornaments worn by women, included *Guluband* (choker), *Hans*, Har, *Hansuli*. These ornaments often used rough gems that were cut and carved by skilled lapidaries. Under the *Mughal*s, the emeralds were carved with religious verses with the belief that these words, symbols or titles would boost the power of stones.

Varieties of neck ornaments worn by men and women are enlisted below:

Name of the Ornament	Description
Latkan and Amala	*Latkan*, which is a precious metal, gemstone-set pendant of various forms, worn singly near the neck or placed in the center of an *amala* necklace.
Mala	*Mala* is a long single or double strand of pearls, alone or interposed with ruby and /or emerald beads.
Guluband (choker)	*Guluband* (choker) is a five or seven rose-shaped gold units strung on silk thread, worn tightly around the neck.
Har	*Har* is along necklace of strings of pearls interspaced with gold units.
Hans	*Hans* is a torque necklace.

Hansuli	The *hansuli* is a rigid necklace. The front surface is mostly enameled with opaque blue enamel. This enamel is in turn shudded in the *Kundan* style with diamonds, rubies, and emeralds in a foliage design. There is a pearl skirting on the front side of the necklace. The reverse side is usually in polychrome enamel. The name of this uniquely Indian style necklace is derived from the collarbone (*hansuli*) on which such an ornament rests. Variation of this basic type is common all over North India.
Champakali	The *champa*, jasmine flower, is symbolic of fertility. The *champakali* motif is a jasmine bud shaped necklace. Each pendant in the shape of a bud is strung together on a thread

NOSE ORNAMENT

Unlike other ornaments that were worn by men and women alike, nose ornaments were meant solely for women. The nose ornaments is worn throughout the sub-continent especially in weddings. It appears that the nose ornaments only appeared in India around the last part of the 16th century, initiated by the *Mughal*s. The earliest evidences of nose ornaments can be found in the *Mughal* as well as *Rajput* miniature paintings. The variety of nose ornaments worn by the women during the *Mughal* times constituted *phul, besar, laung, balu, nath,* and *phuli.*

Different varieties of nose ornaments are listed below:

Name of the Ornament	Description
Phul	The most common type is the stud (*phul*), worn though a hole in the left side and secured by a screw fitting inside the nostril, or by a hook. Its size varies from a small gold ball or diamond to a large flat disc with a highly ornamented surface. The stud may have small attachments like a fringe of hanging chains or small pendants.
Besar	*Besar*, which is a circular, broad gold wire hoop strung with pearls, bung (A bung, stopper or cork is a cylindrical or conical closure used to seal a container.) from the nostril.
Laung	*Laung* is a stud in the shape of a clove, placed in a nostril.

Balu	The ring type nose ornament is known as *balu*.
Nath	*Naths* are worn all over India in different shapes and sizes. The size of a *nath* denotes the economic status of the family of the wearer. In some areas the weight and size of the *nath* increases with prosperity of the family. In hilly regions, women wear large sized *naths* while in lowlands, *naths* are worn in smaller sizes. The custom of using *naths* goes back to Scythians who putted rings into the noses of their slaves to differentiate them from others. There is not even a single piece of evidence of *naths* in ancient Indian literature or sculpture. Later on, it became an integral part of Indian bridal jewellery and was considered as *saubhagya chinha* (auspicious symbol).

Phuli	*Phuli* is a shaped like a bud, the stalk of which is passed through a nostril.

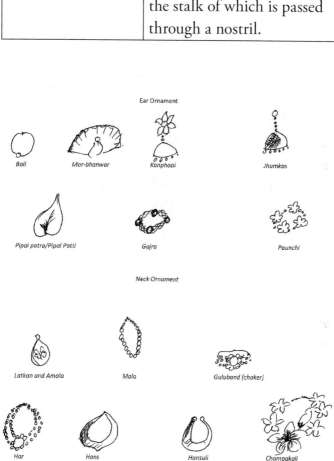

Ear Ornament

Bali

Mor-bhanwar

Kanphool

Jhumkas

Pipal patra/Pipal Patti

Gajra

Paunchi

Neck Ornament

Latkan and Amala

Mala

Guluband (choker)

Har

Hans

Hansuli

Champakali

FINGER ORNAMENT

The finger-rings were amongst the most popular form of ornaments or jewellery. These were worn of all the rings, even the thumbs weren't spared. The Emperors often wore seals, along with rings of diamonds, emeralds and other precious stones. Furthermore, the influence of Hindu astrology can be clearly seen through rings as the use gems associated with the celestial bodies became a vogue. This also indicates the religious tolerance of the ruling and the ruled.

Name of the Ornament	Description
Anguthi	*Anguthi* were designed with different kinds of materials, primarily categorised into ones with bezel (meant to hold a stone or seal) and other without it. The popular *navratna* (nine stones) is quite often used in rings representing different celestial bodies, and it is believed to provide universal protection.
Zihgir	*Zihgir* or the archer's ring was amongst the popular rings worn more specifically by the Emperor.

HAND AND ARM ORNAMENT

Hand as well as arm ornaments were commonly worn both by men and women alike. For instance, armlets and amulets were worn around their forearms, as well as their wrist. Strings of pearls and bracelets of gold and gems were quite popular for adorning the hand and arm. Armlets were often strings of pearls or gemstones; whereas some of the more elaborate some were stylized with patterns. Some of the hand and arm ornaments under the *Mughals* include *baazuband, chur, churin, kangan, jawe, gajra, tad, kara, hathful.*

Name of the Ornament	Description
Baazuband	*Baazuband* were armlet of diverse kinds a one or three part hinged armlet ornament, often with a central inscribed gemstone amulet, tied to the upper arm with cords. Depictions of armbands, often with extremely intricate centerpieces, in ancient and medieval India and later are too numerous to require citation. The typical flexible form having a three-element centerpiece, which came to be synonymous with the word *baazuband,* probably came to Iran from India, most likely in late Safavid times.
Chur	*Chur* is a bracelet worn above the wrist. A smaller variation was called *bau*.

Churin	*Churin* are bangles thinner than the *chur*, and commonly a set of seven were worn together.
Kangan	*Kangan* were rigid, hollow bracelet.
Jawe	*Jawe* are five gold barleycorns (*jau*) string on silk, a pair worn one on each wrist.
Gajra	*Gajra* are bracelet of gold and pearls.
Kara	Kara is peculiar wrist bracelet with animal head terminals.
Tad	*Tad* is hollow tube shape, worn on the upper arm.

Hathful	The *hathful* is part of a bridal jewellery set. The ornament comprises of two finger rings, each linked by chains to a medallion and then finally to a bracelet. The rings, medallions and bracelet are set with emeralds, rubies and diamonds whilst the chain of a gold link design.

Nose Ornament

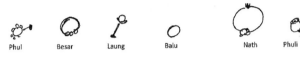

| Phul | Besar | Laung | Balu | Nath | Phuli |

Finger Ornament

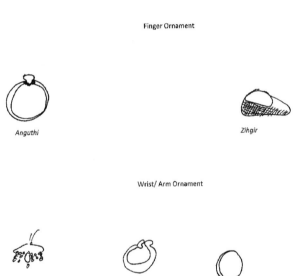

Anguthi

Zihgir

Wrist/ Arm Ornament

Baazuband　　　　*Chur*　　　　*Churin*

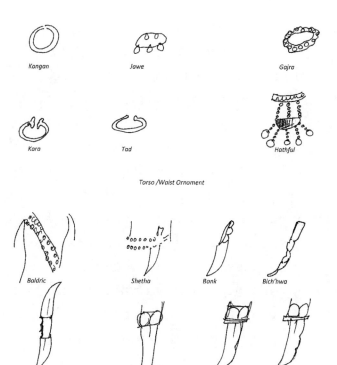

Kangan

Jawe

Gajra

Kara

Tad

Hathful

Torso / Waist Ornament

Baldric

Shetha

Bank

Bich'hwa

Jambia

Jamdhar

jamdhar dolikaneh

jamdhar sehlikaneh

TORSO/WAIST ORNAMENT

Torso or waist ornaments were fairly in style under the *Mughal*s too. In contrast to other ornaments, the men had a wider range of choices, as the masculine torso weren't restricted to merely bodily items. The gem studded sword hilts, dagger sheaths, sword scabbards and *Hookah* mouthpieces. In fact, believe it or not but daggers too were an ornament part from their actual use. They were often given as royal gifts at state levels or ceremonial receptions (*durbars*), in respect of a guest or a deserving noble. The hilts frequently symbolically depicted with animals and birds speaking about the power and status of the wearer. For instance, the pistol grip took the shape of an animal head, such as that of a horse, lion, tiger or antelope. Some of the more common variety of dagger types used is the baldric, shethatype daggers, *bank, bich'hwa, jambia, jamdhar, jamdhar dolikaneh, jamdhar sehlikaneh, kata, khanjar, peshkabz, kamarband, and yakbandi.* In addition to this, jewelled sashes were worn around their waist and often extended into a golden band set with emeralds, rubies and diamonds. Even the

clasps or buckles of their sword belts were not spared from heavy ornamentation.

The waist ornaments worn by women included *chhudr-khantika* and *kati-mekla*.

Varieties of waist or torso ornaments worn by men and men are enlisted below.

Name of the Ornament	Description
MEN	
Baldric	A broad gold brocaded belts with enamelled or gemstone-set buckle known as *baldric*, was worn diagonally on the chest over the left shoulder as an ornament but also to support a sword.
Shetha	*Shetha*-type daggers were worn thrust into the girdle or under a belt, and those with highly decorated hilts and scabbards can be considered as a form of ornament.

Bank	*Bank* is a curved blade and a hilt with a knuckle guard.
Bich'hwa	A doubly curved, double edged blade, resembling a scorpion's tail and a strong central rib.
Jambia	*Jambia* is a double-edged blade with a central rib and a straight, pistol-grip or animal head hilt.
Jamdhar	*Jamdhar* is a straight, broad blade, with two handles.
Jamdhar dolikaneh	*Jamdhar dolikaneh* is a straight bladed dagger, with two points.
Jamdhar sehlikaneh	*Jamdhar sehlikaneh* is a straight bladed dagger with three points.
Kata	*Kata* is a wide, straight, triangular blade dagger.
Khanjar	*Khanjar* is a curved, double-edged blade dagger.

Peshkabz	*Peshkabz* is a straight, single edged, T-shaped sectioned blade and slender point, meant to penetrate armour.
Kamarband	*Kamarband is a* belt of precious metals. Some set with gemstones, are represented in miniature paintings. These could be worn with summer dress or over a sash (*patka*) worn over a robe.
Yakbandi	*Yakbandi* was a sword belt with mountings and a sling with hooks used to support a sword hanging at the left side.
WOMEN	
Chhudr-Khantika	*Chhudr-Khantika* were gold bells string on a gold wire placed around the waist.
Kati-mekla	*Kati-mekla* was a decorative gold belt.

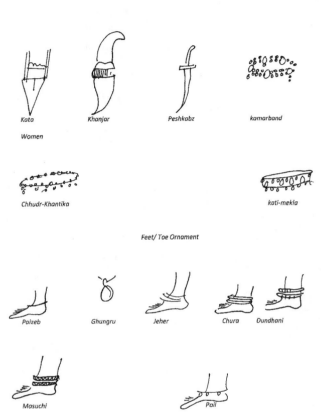

Kata

Khanjar

Peshkabz

kamarband

Women

Chhudr-Khantika

kati-mekla

Feet/ Toe Ornament

Paizeb

Ghungru

Jeher

Chura　Dundhani

Masuchi

Pail

Anwat

Bhank

Bich'hwa

FEET/TOE ORNAMENT

The use of gold for feet or toe ornament is traditionally restricted as it is considered to be a divine metal or the metals of the Gods. Henceforth, using it for foot or toe ornament would be demeaning to the sacred metal. With this in context most of the ornaments intended for feet or toe were made in silver. However, in certain parts of Rajasthan, gold anklet worn on one or both feet by men was seen as an insignia of nobility. Customarily, anklets are worn in pairs all throughout the length and breadth of India by women. Some of the popular anklet amongst women was known as *paizeb. ghungru, jeha* and *pail*. Apart from anklets, toe rings too were in vogue that were worn throughout India that included *anwat, bhank, bich'hwa*. In fact, the slippers of the royalty to were heavily studded with pearls and gemstones.

Name of the Ornament	Description
WOMEN	
Paizeb	*Paizeb* an ankle bracelet, usually of chain construction, in precious metal, with or without gemstones.
Ghungru	*Ghungru* constituted small gold bells, six on each ankle, strung on silk, worn between the *jehar* and *pail*.
Jeher	*Jehar* refers to a three gold anklets worn together in descending order: the *chura, dundhani, masuchi*.
Chura	The *chura*, is a combination of two-part hollow tubes joined as a ring.
Dundhani	*Dundhani*, is like *chura* but engraved with a design.
Masuchi	*Masuchi*, is similar to *dundhani* but differently engraved.
Pail	*Pail* was a type of anklet (called *khalkhal* in Arabic).

Anwat	*Anwat,* is a ring for the great toe.
Bhank	*Bhank* is worn on the instep, triangular or square.
Bich'hwa	*Bich'hwa* was worn on the instep, shaped like half a bell.

AMULETIC JEWELLERY

Amuletic jewellery constituted an important of *Mughal* ornaments. With the diversity of religious communities in India, amuletic jewellery is used far and wide. The purposes of these ornaments are considered to be apostrophic that act on behalf of the possessor to help him or her overcome natural forced that affect him or her adversely or positively. The variety of the effects from these prophylactic and homeopathic amulets were varied such as protection against particular illness, render the wearer unaffected to the effects of sorcery, the possibility of accident, coercion from the environment or voracious animals. In addition, a particular sort of amulets counteracts the evil control of the ever present wickedness that is often placed on children, who are believed to be especially subject to evil influences.

The amulets can be worn on any part of the body unless specified. However, these are mostly worn around the neck, arm or even as bracelets. Amongst popular amulet form worn by Muslims, and more commonly by children is a small metallic container that holds within

itself an inscription (a short invocation (*surah*) from the Holy Quran) on a paper or parchment. Apart from these, amulets are designed using stones such as bloodstone, agate, carnelian, lapis lazuli, crystal, and jade. All of these stones were considered to seize special prophylactic qualities; amongst these jade (nephrite) was considered most efficacious. Jade's popularity lies in the fact that resist the action of poison, protects against direct lightening amidst others. The amuletic stones were engraved either on one side or both in accordance to the adherence to the guidelines instructed by religious cleric, wherein the carving was accomplished by an expert in lapidary owing to high cost of the stones used.

The *Mughals* adopted several Hindu customs and traditions, and one such example is the use of *navratna* as ornament. The Emperors of the *Mughal* dynasty often entered into matrimonial alliances with Hindu princesses and thereby accepted some of their rituals and superstitions. The *navratna* based upon Hindu astrology is profusely used in different varieties of jewellery from head to toe. The legends of the *Mughal* opulence even impressed their contemporaries

in the west during the 17th century indicated by some of the survived enamel decorated items.

Majority of the chronicles of the *Mughals* period extensively account the jewellery worn by men unlike contemporary chronicles of European courts that account solely of the jewellery worn by the queen and the high-placed ladies. The opulence of the *Mughal* jewellery can be concluded by the high-respect ordained by their patrons to the goldsmiths, and the high rank in the societal structure.

CHAPTER 5

Techniques of Ornamentation Used

Enamelling/*Minakari*

The art of *minakari* can be simply understood as the art of melting glass into the metal. This intricate art is believed to have been introduced in Jaipur by *Raja Man Singh* of *Amber* with the calling of some skilled workers from the city of Lahore. The art took impetus over the course of time, and Nathdwara and Alwar became other centers of fine quality enamelling apart from Jaipur. Enamelling was accomplished primarily to check the quality of gold as the saying goes, 'the purer the gold, the brighter the enamel'. Henceforth, the quality of the gold used, was of high standard of purity, ensuring a fine kind of enamel. In some instances, silver has also been used to accomplish enameling.

The bright colours are produced by fusing mineral substances on to the metal surface in fire. The pre-existing art in India got extensive patronage under the *Mughals*. In fact, *Ain-i-Akbari* accounts the art of *Minakari* wherein the *minakar* is referred to polish his enamels and work on cups, flagons, rings etc.[15] The craft was known in cities of Lucknow and Varanasi too but it reached its highest stage in Jaipur.

An ornament was crafted at different stages before the final output. First, it is handed over to the *'chitera'* (artist) for the desired design which is then outlined by the *'thathera'* (engraver). Lastly the ornament goes to the *meenasaz* (enameller), who adds the different colours with brushes onto the engraved design. The exterior of the pits in the gold is decorated with etching, which serves a dual purpose to allow the enamel adhere firmly, as well as add to its beauty, by the magic of the light and shade produced by the transparent colours. The article to be enamelled is positioned on a plate of mica in the furnace to keep it from direct contact with fire. It is extremely cautiously

[15] *Ain-i-Akbari*, Abul Fazl. An account that was written by the state chronicler, Abul Fazl under Akbar.

secured while cleaning or dying so as to prevent any dust getting attached to the surface.

The enamel colours are applied to the metal surface and heated in accordance to their hardness or power of resisting fire. The hardest colour is applied first so that it will fuse to the metal firmly, while the soft colours are heated due to constant heating. There is a distinct difference in the examples of Persian and Indian works in terms of designs and tones of colour.

Kundan

During the *Mughal* period, the art of setting of gems into gold was quite popular. This technique of ornamentation was referred to as '*Kundan*'. The skill of setting gems with the use of claws came into vogue much later to India during the 19th century from the West. In India, the artisans used *lac* (a type of natural resin) to set gems, which was often combined with enamelling. The combination of these two techniques made the ornaments even more aesthetically appealing, with *kundan* work on the front and enamelling done on the back, often called 'Meena *Kundan*'.

The prime use of enamelling was the item with *kundan* work more durable as the enamel would prevent it from coming in contact with the wearer's skin.

Kundan jewellery got great patronage under the *Mughal* period, with some of and the most striking examples from this era. Some of the oldest specimens of jewellery in India were made from 24-carat pure gold. Some of finest specimens of *Kundan* jewellery are from Bikaner and Jaipur. In accordance to historical accounts, the *Kundan* jewellery was worn solely by kings and queens.

The pieces were accomplished by skilled craftsmen, as the completion of the ornament often required more than one craftsman. The engraver chased the designed, the stone setter encrusted the stone with *lac* as the base, and then further polished and enameled by other craftsmen. The craftsmen received royal patronage, and often were expected to design customised designs with no pressure of set deadlines for deliverable.

Filigree

Filigree is amongst the earliest techniques that were employed in India to style ornaments. The work is primarily done in pure silver that is casted into long bars, and then cut into small pieced to be beaten into wires by using *jantra*. These wires were carefully arranged and then demented on a sheet of mica to produce intricate patterns. The decorative technique employs twisting and plaiting of the wires of gold and silver that are followed by cleaning and brightening the surface to get a snowy appearance. In contrast to the common belief, the technique *Filigree* work did not really originate in Bengal rather was taught by the 'Oriya' people (from the state of Orissa) who mastered it. Ornaments crafted through this technique influenced bangles, bracelets, necklaces, pendants, ashtrays and much more.

Thewa

The technique of *Thewa* is commonly misinterpreted as enamelling. The art was erroneously described as enamelling during a survey conducted to collect arts and crafts of India in the late 19th and early

20th century. Nevertheless, the two techniques are quite different in terms of appearance as well as technique. The technique is primarily practiced by the artisans in Pratapgarh for generations who have produced extraordinary objects that serve ornamental as well as utility purpose using the technique.

Thewa technique can primarily understood as encasing of a coloured glass by a frame of gold. The most common colours used were red, blue and green. The foil of gold is affixed to the glass through an acid treatment, and a thin layer of silver foil is affixed on the other side to achieve a uniform luster. Some of the most exquisite articles of *Thewa* work are kept in the Metropolitan Museum, New York that was prepared about 100 years ago.

Thappa **technique**

Thappa technique involves the molten metal to be hammered into a desired shape that was an ideal option to prepare solid (*thos*) ornaments. In case, the technique was to be used for preparing hollow (*pola*) ornaments, the two halves of the ornament

were produced first and then joined together with the help of soldering. This technique was used to prepare a variety of ornaments such as earrings, bracelets, amulets and much more. The smaller units of an ornament are prepared first and then cleaned followed by *naksh* or engraving, that were often enameled.

<u>Casting</u>

Casting technique can be dated back to the Indus Valley civilization, indicated with the evidence of casting moulds. This technique was used in the ancient times when man made a shift from stone to metal for tools and ornaments. In this technique, the model of the ornament was made by hand using resin or brass with a vent. This model is filled with the molten metal and the vent is sealed with clay, and then fired. Owing to the gradual heating, the metal takes the shape of the mould, and henceforth an exact shape of the model is made in gold and silver. This appears to be a cruder version of the 'cire-dire' or lost wax technique of the modern times.

Engraving

The gemstones were engraved too for ornamentation, a technique used during *Mughal* period. They acted as propaganda items that were indicative of its wearer. The example of engraving included rings pendants etc. For instance, portraits of *Mughal* Emperors were engraved on precious gemstones.

CHAPTER 6

Gems

<u>What is a gem?</u>

A gem is any mineral, cut and polished for ornamental purposes. There are more than three thousand known minerals, and any of them could be used as a gem. Some of the popular used gems include diamonds, sapphire, emerald, hessonite, red coral, topaz etc.

Whether intended for religious purposes or as personal adornment, jewellery articles of various kinds have been known since the earliest times. The rationale for wearing these small but captivating objects have not changed much over the millennia. Jewellery of gold worn on the person or as garment accessories has always been a symbol not only of wealth of the wearer's social status. In addition to being worn, jewellery objects were often presented as wedding and birthday

gifts and were placed in temples as offerings to gods and in tombs to honour the dead.

Until the Hellenistic period, only metals were employed in jewellery-making indicated by the extensive use of precious and semi-precious stones in Greek Jewellery. Gemstones are among man's most treasured objects. The histories of few gemstones can be traced over a span of centuries. Gems are associated with wealth, prestige, status and power just as gold and silver. In the earliest periods of civilization, people became curious about natural objects, including minerals. Worldwide affluence has created an unprecedented demand for gems of fine quality, greatly increasing their price. Political problems in gem producing areas have created restrictions in the supply of gem materials, further affecting prices of the gems.

What is important in gems?

The colour should be true. This would mean that, a red ruby should be red-a clear red, not any milky or dull red. A naturally translucent stone should be translucent. Inclusions should

be small. Natural stone do have inclusions, but it is important to make sure that the stone does not lose all of its beauty because of dull clouds. The cracks should be very, very small, or non-consistent in the gems, as these can split with the slightest of the physical pressure.

This clearly indicates that "precious" is a marketing term, applying to any expensive item. Garnet has always been regarded as semi precious, so it is obvious that these terms, as applied to gems, have little relevance or meaning. Therefore, aside from considerations of historical usage, the terms "precious" and "semiprecious" should be completely abandoned. In order to be considered a gem, a mineral must have beauty, durability, and scarcity, according to most authorities.

History of Gems

Gems are considered a gift of earth. They are manifestations of the universal forces of 'deity', 'goddess', 'fate'-which created all that is, all that was, and all that has potential of being. Gems are magical batteries which contain and concentrate the earth's energies. Through ages humans

have relied on these precious stones to ensure conception, ease child birth, guard personal safety and health, and protect the dead.

More recently, stones have been used in magic for internal or external changes. These enchanting pieces of stones like herbs, colours, metals, numbers and sounds, aren't inert. They may sit quietly in the earth for millions of years but they are active, powerful tools possessing energies which can and do affect our world.

For thousands of years, gems attracted kings, queens and the noble class. Gems were a means to show their wealth and were a sign of glamour. But in today's world gems are much more than that. Gems are used in creating medicines; they are also used in designer jewelleries and watches. Gems are used by astrologers to find solution to their client problem and used by magicians seeking mystic powers and spiritual knowledge.

Significance of Gems

A number of modern experiments have proved beyond doubt that gems have a noteworthy effect

on our lives. The principles that were laid down by ancient Indian Sages are being proved with the help of modern sciences. According to the age old *Ayurveda* (a religious epic of Indian sciences and mythology), cosmic energies permeated the universe and conditioned life through fundamental colour.

There exists a relationship between these cosmic forces and the colour if the rainbow, of gems, of metals and human beings. Each fundamental colour has a corresponding stone acting radiating center of energy and each person has a gem that is beneficial to him.

Indian cut is the type of cutting of gemstone that is imperfect and without symmetry, as has been sometimes in India, especially before the development of the modern techniques of diamond cutting. Sometimes, it is called '*Mughal* (Moghul) Cut'.

Nine Gems or *'Navratna'*

In contrast to the west, different gems have been recommended to compute with the date and

month of birth. The matrix of numerology and signs of the zodiac, in Indian astrology is not simple. A number of factors have to be taken into account and a horoscope (*Janma Patrika*) has to be prepared with the position of the various celestial bodies and their influence during various periods of life before gems are advised for wear. However, the *navratna* (nine gems) is worn by almost all people who can afford it. The stones stand for wealth, happiness, renown, longevity, honour and mental peace.

Some weight is prescribed for the stones, but the gems should be flawless and genuine. An auspicious time and day should be determined for the wearing and if necessary a ritual fire or *puja* performed. The gems should be set by a knowledgeable jeweler (in a particular format) either in gold and silver.

Even the *Ayurveda* believed that cosmic energies permeated the universe and conditioned life through the fundamental colours. *Ayurveda* believes that there exists a relationship between these cosmic forces and the colour of the rainbow, of gems, metals and human beings. Each

fundamental colour has a corresponding stone acting as a radiating center of energy and each person has a gem that is beneficial to him.

These corresponding nine gems are set into a ring or pendant is determined by the astrologers and in some cases may vary according to individual horoscopes. One of the more common setting has the ruby, representing the sun in the centre; the diamond (*vajra*) representing Venus in the east; a sapphire (*indranil*) representing the Saturn in the west; a Cat's eye (*vaidurya*) representing *ketu* in the north; a coral (*moonga*) representing Mars in the south; an emerald (*marakatam*) representing Mercury in the north east; a hessonite (*gomedha*) representing Jupiter in the north west of the *Navratna Pariksha*.

According to age-old belief a person who wears a *rudraksh* along with pearls, corals, crystals, cat's eye, silver and gold, propitiates Shiva. The *Navlakha Haar* or necklace worth nine lakhs also figures in many a folk tale. It is said to protect the wearer from danger, hunger, thirst and death. The sparkle of this necklace gives enough light to serve as a lamp.

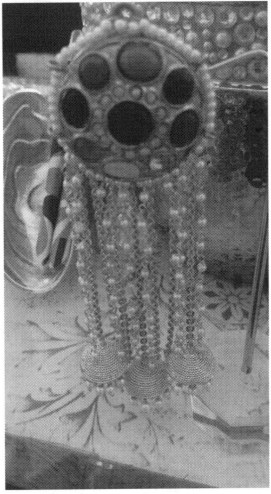

Navratna **or Nine Gems studded in an Ear Ornament.**
Courtesy: Renu Manjunath from the 'Karigari
Collection'

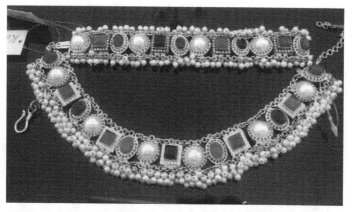

Navratna **or Nine Gems studded in a necklace.
Courtesy: Renu Manjunath from the 'Karigari
Collection'**

But the recent opinion is that the *navratna*
cannot be worn by one and all, for it may result
in negative effects for the wearer. So, it is better to
consult an astrologer before purchasing this item
for everyday use.

The precious nine gens are also known as the
planetary stones or the birth stones because they
are associated with particular planet and a specific
duration of a year. The nine precious stones are
ruby, pearl, yellow sapphire, diamond, emerald,
blue sapphire, red coral, gamed and cat's eye. For a
total rounded protection barrier, it is the *navratna*
that is relied upon each planet; the sun and the

moon are taken care of. Now, the wavelengths of corresponding planets are known and they are:

For centuries, gems have been admired for their luster, radiance and beauty. But, apart from their beauty, the influence of gems on human life is far reaching. They prove to be advantageous if wore in accordance with the laws of Astrology and under expert advice. In order to get a clear idea of the affect of gems, radiations were allowed to pass through these gems. Therefore, as a result following wavelengths of light were reflected from each gemstone. On comparing the radiation of gems with their corresponding planets we can ascertain that gems cam play a significant role in human life and activities.

PLANET/ CELESTIAL BODY	GEM	WAVELENGTHS
SUN	RUBY	70,000
MOON	WHITE PEARL	70,000
MARS	RED CORAL	65,000
JUPITER	YELLOW SAPPHIRE	50,000
MERCURY	EMERALD	75,000
VENUS	DIAMOND	60,000
SATURN	BLUE SAPPHIRE	79,000
RAHU	GOMEDHA	70,000
KETU	CAT'S EYE	70,000

VARIOUS GEMS

Diamonds (*Heera*)

A diamond is the hardest naturally occurring substance and also one of the most valuable. It is the only gemstone composed of a single element, and is the most lasting of all gemstones owing to its hardness. Diamonds are crystals made up entirely of carbon that have six faces, but most form octahedrons, with eight faces. Natural diamonds probably form in the earth's upper mantle-the zone beneath the crust-where high temperature and pressure cause the diamonds to crystallize. The diamonds are later brought to the earth's surface through a volcanic activity. A diamond does not dissolve in acid, but can be destructed through intense heat. In case, a diamond is heated in the presence of oxygen it will burn and form carbon dioxide. If a diamond is heated without oxygen, a diamond will turn to graphite, a form of carbon so soft that is used as a lubricant.

Diamonds have great power to reflect light, blend rays of light and break light up into the colours of the rainbow, but to produce the greatest possible

brilliance in a diamond, many little facets or sides must be cut and polished on it. Each tiny facet must be exactly the right angle in relation to other facets.

At some stage in the 1400s, diamond cutters learned how to shape and polish a stone by using an iron wheel coated with diamond dust. As people learned more about diamonds, they discovered the shapes that gave the greatest brilliance. The style of cut often seen today is the round shape with 8 faces, which is called the brilliant. This type of cutting began in the 1600s.

The 4Cs key to diamond quality. To establish a diamond's quality, jewellers examine each of the 4Cs-cut, clarity, carat weight and colour. The combination of the 4Cs determines the value of a diamond. For example, a colourless diamond is at the top diamond quality. But if it lacks clarity, is small, or not well cut, it will be of a lower value. The finest stones possess the rarest quality in each of the 4Cs and are the most valuable.

Sukra or Venus is harmonized by diamond. *Sukra* represents luxuries, romance, partnership, wealth, beauty, arts, comforts, jewellery, happiness and

vehicles. Diamonds are also associated with these attributes. *Sukra* or Venus has since antiquity symbolized beauty, not just in material life but inner life as well. Diamonds high lustrate symbolises the refined liveliness and loveliness of nature within and around us. *Sukra* or Venus in the human physiology corresponds to the activity of the pars reticulate. The structure in the physiology refines and controls action in the limbic system related to instincts, feelings and emotions etc. This action is associated with those impulses in the physiology that correspond to the qualities of life influence not strongly by *Sukra*.

Emeralds (*Panna*)

The name emerald is applied to the green variety of beryl, which gets its colour from chromium. It is a natural silicate of aluminum and beryllium. Emeralds occur in several shades of green. The dark or bright colour of meadow grass is the rarest and most sought after. These stones are the most valuable and indeed, one of the jeweller's favourite gems.

Old mine emeralds rank amongst rte most rare emeralds in existence today; they have a following

of their own, and have always been a true connoisseur's delight. There are a very few such emeralds in circulation today- understandably so, because those who possess them do not wish to part with them, they are yellow-green in shade, and possess a pleasantness and attraction of their own.

Old mine stones were always worn by Maharajas, no one really knows where the old mine originally existed. There are several theories regarding this; some believe the b mines were Columbian (either Muzo or Chivor); others believe the old mines existed in the South Russian steppes, while a few others conjecture that it was a mine that supplied fine emeralds in India, and was one whose whereabouts are totally unknown today. The ancients said that acquiring fine emeralds would help one strengthen his memory or become an eloquent speaker.

Velvety green in color, most emeralds are marred by cracks and inclusions, which greatly decrease their value. It is also known as ***Panna*** in Indian mythology. The emeralds with deep velvet green to grass green colour, radiant, smooth, and

transparent and with bright rays, with water mark, and without any dots or spots, is the best and most auspicious gem. A flawless emerald, like a flawless ruby, is extremely very rare and precious.

Emerald helps in acquiring wealth. The native would be blessed with children, intelligence and good fortune. It also bestows good health, wealth, longetivity and happiness. It brings advancement in profession, name, fame and honour. It controls BP and nervous problems. Emeralds was said to have the power to predict events. Its owners could into the future. An emerald is a perpetual reminder of spring. Emeralds are the birthstone for May.

Pearls (*Moti*)

The pearl is not a precious stone, but its beauty and its importance in jewellery, making justify its inclusion in the same in the same class as it comparisons the ruby, the emeralds and the sapphire. The pearl is often called the "queen of the sea", and harmonizes *Chandra*, the moon which directly influences emotions, mind, affluence, and public. *Chandra* influences the

seasonal, monthly and daily cycles and rhythms in the physiology and our emotions. *Chandra*, the moon occupies a central role in the solar system and our physiology.

Some of the best specimens come from the Indian Ocean, the Persian (Bahrain) and Ceylon (Manaar). The value of a pearl depends on its shape and weight, which is expressed in grains (a grain is 0.05gm), its colour, which may be white, pink, yellow, grey or even black according to the species of oyster it comes from, and its sine, which is known as the orient.

Pearls are a word of magical import for many people, being a symbol of beauty and purity. It gave rise to legends of mystical birth from the seas. It is not only a symbol of purity, wealth but also of love. It is believed to ensure a happy conjugal life and protection from widowhood. It also provides vitality and wisdom. The persistence with which medical properties have been attributed to pearls, it is strange that ancient peoples of completely different races and customs and separated by thousands of miles, simultaneously became interested in the curative virtues with which pearls

are endowed. It has watery and lunar elements owing to its origin in the sea, thus balancing emotions, especially for water signs. It is known as a 'stone of sincerity' bringing truth and loyalty to a cause. A favourite of royal families, pearl continues to appear among important ceremonies because of its purity and dignity. The ones with a rosy sheen are the most coveted and expensive.

Pearls comes in while, black and with tinges of yellow, blue, salmon ink, red, brown and green. Although the pearls are an organic origin but it is composed of mineral matter and occurs in the pearl oyster during the two spawning seasons of each year. The luster of pearl is dependent on the layers of the ocean beds. In India, there are two centers of pearl diving both off the southern coast of Tamil Nadu and Andhra Pradesh. The Pearls with a rosy sheen come almost exclusively come from the Persian Gulf. A pearl is considered flawless if it has cracks on the skin, a joint appearance, a mole, is lusterless, and has mud or other material inside.

Ruby

The ruby is corundum, and several qualities of ruby known by different names. The Burma ruby, known as the 'ruby of the rubies, ranges from scarlet red so called 'pigeon's blood', to crimson or even purple-violet. The Siam ruby, is the colour of the lees of wines, and darker than the Burma ruby.

All the corundum's (ruby and sapphire) have rhombohedra crystal (six faces composed of equal lozenge (rhomboid) shapes). Rubies have a considerable sparkle, their refractive index being 1.76; they have the property of shining brightly.

Ruby is the stone of the sun, and wearing of the ruby will protect the native from the harmful effects of the sun's afflictions. Ruby is in red, tallow, violet, mixed red and blue colour. Wearer of a ruby is likely to be gifted with intelligence and knowledge. The subject would be blessed with children, honoured by others and receive government favour. Ruby will protect one from ill-health, enemies, success in administrative fields, freedom from troubles, debts and diseases. It ensures long life, and cures heart diseases.

Opal

Opal comes from the Latin word opalus which means to see a change in colour. Chemically, opal is hydrate silica, similar to quartz. Silica (silicon dioxide) is a hard, white or colourless substance that us in the form of quartz, enters into the composition of many rock, and is contained in sponges and certain plants. The needle in the mouth of the female mosquito is made of silica. Flint, sand, chalcedony, and opal are examples of silica in a different forms.

It took the development of the electron microscope to work this out. Precious opal is made up of tiny uniform spheres of transparent hard silica, which fit together in an orderly here dimensional frame, sitting in a "bath" of silica solution. It is the orderliness of the spheres that separates precious opal from common opal.

Light passes through the transparent spheres in a direct lone, but when it hits the 'bath' of silica, it is bent and deflected at different angles, thus producing a rainbow effect. In accordance to the size of the spheres, varying colours of the spectrum are diffracted. It is a combination of deflection

(bending) and diffraction (breaking up) of light rays that creates the colour in opal. If you move the stone, light hits the spheres from different angles and brings about a change in colour. The name opal actually means 'to see a change in colour'. The way in which colours change within a particular stone as it is rotated and tilted is called the stone's play of colour.

The size of the spheres has a bearing on the colour produced. Smaller spheres bring out the blues from one end of the spectrum. Larger spheres produce the reds from the other end. The more uniform the spheres are placed, the more intense, brilliant and defined the colour will be.

Sapphire

The colour of the sapphire varies according to its source. The Kashmir sapphire is the most sought after indeed, it is virtually unobtainable because the original mine is no longer worked. It colour is kingfisher blue with a slight velvety opacity. The Ceylon sapphire is a slightly lighter blue and more transferred. The finest Ceylon sapphires are almost kingfisher blue. The Burma sapphire is darker than the Ceylon and more transparent

than the Kashmir. The characteristic colour of the Burma sapphire is royal blue. The Australian sapphire is darker than the Burma and regarded as the poorest and cheapest type. Te substance of sapphire is e hardest after the diamond. This is one of the reasons for the clarity of engraved sapphire throughout the ages.

Blue Sapphire

Blue sapphire is commonly found in Myanmar (Burma), Thailand, India, Sri Lanka (Ceylon), Tanzania, Afghanistan, Australia, Brazil, Cambodia, Malagasy Republic, Malawi, Pakistan, Zimbabwe (Rhodesia), United States (Montana, North Carolina). Although found in a variety of colours, blue sapphire is the colour most people think of when sapphire is mentioned. Very light to very dark (almost inky) shades of blue are found. The more vivid colours (without being too dark) are the most valuable. Blue sapphire is usually heat treated to produce, intensify or lighten colour and improve colour uniformity and appearance. A blue sapphire is a radiant, transparent, soft touch gem which gives off rays from within. The blue sapphire however, is said to

suit all temperaments and may not be universally auspicious despite its purity. Best sapphires come from Kashmir and are called '*mayur neelam*', or peacock blue. Its most important quality is that it does not change colour in electric light but instead throw off navy blue colour.

Yellow Sapphire

Yellow Sapphire is commonly found in Myanmar (Burma), Thailand, India, Sri Lanka (Ceylon), Tanzania, Afghanistan, Australia, Brazil, Cambodia, Malagasy Republic, Malawi, Pakistan, Zimbabwe (Rhodesia), United States (Montana, North Carolina). It can be confused with Mexican fire opal, or orange citrine. Yellow sapphire is usually heat treated to produce, intensify or lighten colour and improve colour uniformity and appearance, yellow sapphire is occasionally irradiated to provide temporary intense yellow or orange colour.

Pukhraj as it is called in Indian astrology, the stone in the purest form should have eight qualities: it must feel leavy when placed on the palm of the hand, appear clean, pure, be free of spots, should be solid with no layer, have a

yellow hue, feel smooth to touch and its radiance must improve when rubbed on a testing stone. A *Pukhraj* with blemishes like a blackish tinge, asymmetry, spots or a whitish-yellow colouring is regarded inauspicious and is not used in jewellery.

Yellow sapphire harmonizes and benefits Guru or Jupiter, the largest *graham* (planet) in the solar system. Guru is the major instructor or teacher and influences action with the highest order and balance. Guru guides action in the most harmonious and uplifting manner and balances inner and outer input while simultaneously performing and monitoring action. Guru or Jupiter's influence in the human physiology is through the globus pallidus. It gives balanced and higher-order instructions, balances and maintains harmony between inner and outer input manages and executes complex systems and enlivens activity in the brain while guiding action.

It signifies knowledge, wisdom, virtue, fortune, justice, education, future, religion, philosophy, devotion, children, distant travel, spirituality, truthfulness, prosperity and charity. Yellow

sapphire is believed to make one intellectual, charitable, religiously inclined and respectable towards elders. It ensures wealth, honours, name and fame. It also acts as a protective charm. It ensures comfort in life. One can fulfill all the desires by wearing yellow sapphire. It is intended for those who find obstruction in the progress of their educational field, or those who suffer from property matters should wear yellow sapphire for removal for their difficulties.

Red Coral (*Moonga*)

Red coral generally found in red and *sindoori* (vermillion) colour. The use of the coral in jewellery dares back to the Romans who considered it auspicious worn in amulets. It is because of its auspiciousness, the coral, though not a precious stone has been given a coveted place in *navratnas*. Red coral is believed bestow good health, longevity, courage, name, fame and happiness. The native would be blessed with children, intelligence, good fortune and success in professional life. It cures all kinds of mental diseases, physical diseases, and difficulties. Its use

also helps in removing impediments that could e delayed is one's marriage.

Hessonite (*Gomedha*)

Hessonite or *Gomedha* is not auspicious. The best *gomedhas* comes from Sri Lanka. In India the stone is found in Kashmir, Bihar, Kullu, Shimla and Coimbatore. *Gomedha* represents *Rahu*, the ascending node of the moon. Its natural significance includes worldly desires, worldly benefits, laziness, gratification, and ignorance. It is by nature unpredictable and creates sudden changes and influences, rigidly and passion. It is similar to *Sani* or Saturn in its nature and influence.

By tradition, *Rahu* is known as the 'head of the dragon'. In the human physiology, *Rahu* corresponds to the head of the caudate. The caudate is involved in the control of the saccadic eye movements (the abrupt short shifts of focus in the eyes). The caudate influences memory in relation to orientation in space, and is responsible for our ability to change behaviour patterns. The *Rahu's* activity can be harmonized by wearing *Gomedha*.

The Ceylon *Gomedha* is of honey colour. Its use would bestow good health, win over enemies and bring wealth and prosperity to its owner. It cures skin diseases, gives knowledge and intelligence. It promotes good education, and ensures improvement in the profession. One gets quite active by wearing *Gomedha*. It can give it can give unexpected wealth to its wearer. It bestows a very happy life, and the enmity of relatives disappears.

Garnet

It occurs in Sri Lanka (Ceylon), Madagascar, Brazil, Sweden, Australia, Myanmar (Burma) and the United States. The appearance ranges from bright orange to darker orange and red, also known as Spessartite garnet. It is named after the Spessart District in Bavaria, Germany. It is likely to be confused with other garnets and imperial topaz.

Garnet is a Gem for all seasons. The oranges of autumn leaves, the glowing red corals of a winter fire, the sparkling green of a summer field, and the beautiful pinks and of spring flowers, garnet is a gemstone for all seasons. Garnets are a closely related group of gemstones that are available in

every colour. Dark reds, tangerine orange, vivid lime green, soft bluish-pink, garnet is all these colours and more.

These are garnets that change colour in different light, translucent green garnets that look like jade, garnets with stars, garnets that have been mined for thousands of years and garnets were just discovered in the last decade. Garnets have long been carried by travellers to protect against accidents far from home. In ancient Asia and American Southwest, garnets were as bullets because the glowing red colour was said to increase the intensity of a wound. Garnet is legend light up the night and protect their owners from night mares. It is believed that Noah used a garnet lantern to navigate the Ark at night. The ancient world is full of praise for the carbuncle, the glowing red coal of a gemstone we now known as garnet. Garnet is the birthstone for January.

Topaz

It is commonly found in Brazil, United States, Ceylon, Myanmar (Burma), former USSR, Australia, Pakistan, Mexico, Tasmania, Japan, Africa. Topaz and citrine are the birthstones of

the month of November. Topaz is the gem of setting sun. Topaz is a very powerful amulet that protected him faithful against harm. The association of topaz with Jupiter, who also is the God of the sun, makes it even more significant. Topaz sometimes has the amber gold of fine cognac or the blues. Some rare and exceptional topazes are pale pink to a sherry red.

Jade

It is believed to have been introduced by a merchant from central Asia in the *Mughal* court. It gained immense popularity in the *Mughal* period. It was used not only for vessels but also for jewellery (especially amuletic jewellery). A name that for many years was generally applied to two distinct minerals, jadeite and nephrite, having different chemical compositions and other characteristics (although jade is still often used to refer them indiscriminately). They resemble each other, both being hard, compact, and usually light green with white markings ranking to emerald-green, but found in a wide range of colours. Both are too hard to be carved, and are found usually in Central Asia.

BIBLIOGRAPHY

1. Bhushan, Jamila Brij, *Masterpieces of Indian Jewelry,* Taraporevala, Bombay, 1979

2. Carpenter, Bruce W., *Ethnic Jewellery from Indonesia: Continuity and Evolution,* Editions Didlier Millet, Singapore, 2011

3. *Gioielli dall'India dai Mogul al Novecento, La Rinascente,* Milan, Italy, 1996

4. Translated by Irwine, William, *Storio do Mogor, Niccolao Manucci Indian Text Series,* The Government of Indian, London, 1907

5. Translated by Jarrett, Colonel H.S., *Ain-i-Akbari, Abul Fazl Allawi,* The Asiatic Society of Bengal, Calcutta, 1891

6. *Kalidi, Omar, Romance of the Golconda Diamonds,* Mapin Publishing Pvt. Limited, 1999

7. Krishnan, Usha R. Bala, *Dance of the Peacock: Jewellery Traditions of India,* India Book House, 2001

8. Mack, John, *Ethnic Jewellery,* British Museum Press, London, 1988

9. Translated by Rogers, Alexander, *Tuzuk-i-Jahangiri, Emperor Jahangir, Emperor of Hindustan, 1569-1627,* London Royal Asiatic Society, London, 1909

10. Sharma, Ramesh Chandra, *Alamkara: 5000 Years of Indian Art,* National Museum Singapore, The National Heritage Board Singapore, Singapore, 1994

11. Sofianides, Anna S. and Harlow, George E., *Gems and Crystals from the American Museum of Natural History (Rocks),* American Museum of Natural History, Simon And Schuster, New York, 1990

12. *Treasury of the World: Jeweled Arts of India in the Age of the Mughals*, Thames & Hudson, 2001

13. Untracht, Oppi, *Traditional Jewelry of India*, Thames and Hudson, 2008

Printed in the United States
By Bookmasters